G000075125

Dirt Road Visionary

Poetry and Photography
By
John Charles Griffin

Where an author is confused, so will be the reader. Stay on the ground, remain focused and keep it simple. – J. Griffin 2019

Acknowledgments

Caroline Aiken, Gus Arrendale, Edwin Atkins, Big Island Bees, Jessica Betts, Sandy Blue Sky, Diana Blair, Richard Brent, David Byrd, Kevin Cantwell, Adrienne and Daniel Cloud, Gena Connally, Rex Dooley, Matt and Lori Garrett, George & Mary Lou Griffin, David & Judy Griffin, Harold Griffin, Krista Hall, Roseanne Harrell, Kodac and Patty Harrison, Angie Henigman, Paul Hornsby, Mama Louise Hudson, Monroe Hudson, Gilbert Lee, Livingston Properties, Adam Mosely, Nick Norwood, Pool Sharks & Mermaids, Jeff Payne, Willie Perkins, Michael Pierce, Judy Powers, Frida Raley, Brenda Stepp, Alexis Vear, Katherine Walden, Randy Wesson, Kirk and Kirsten West.

Back cover photo insert credit – "Cooper's Hawk chasing Red Tailed Hawk. Special Thanks to wildlife photographer David Byrd.

Back cover notes: Coppage Road east of Hahira, Georgia, adjacent to the former Howard and Carrie Mae Griffin homestead, a magical gathering place for generations of their children and grandchildren. This road has since been paved. Photograph by J. Griffin.

1954 Chevy Belair, black sedan photo – Special Thanks to Matt and Lori at Garrett's Transmission in Griffin, Georgia for the junkyard tour.

Gas pump on cover and motorbike, Author photos from the Les and Leslie White Collection at Juliette Mill.

Reviews

"A signed copy of John Griffin's first book, "After the Meltdown," sits on my coffee table in The East Village." - Steve Earle

John Griffin's awesome collection of thoughts is like a double bar-reled blast from a sawed-off shotgun scattering a beautiful pattern of thoughts and images at a stationary target. His writing is damn good." Charles Ellis – Savannah Artist @ Pojo Pointe

"Reading John's collection of poems triggers hauntingly beautiful memories of yesterday and of years gone by. I read with my eyes, listen with my heart and laugh with my gut as I flip through the pages of my friend's portrait of life. With coffee in hand, it's the best way to start a day." - Sandy "Blue Sky" Wabegijig

"John Charles Griffin's captivating poetry and photographic imag-ery connects the dots between rural and metropolitan, southern culture and world's beyond."
 -Edwin Atkins – Retired Motion Picture Industry Executive

"John Griffin's photography makes a telling complement to his poetry. His images help place us in the world of his poems, a world where the Brosnan Yard Coal Tower sits cheek to cheek with the Atlanta skyline in this South of endless contradictions. Griffin's images make us feel the heat. The best word choice here is palpa-ble."
- Laurence Fennelly, Arts and Culture Columnist.

"Another fresh helping of deep-fried Southern poetry from John Charles Griffin, John's original words as an author come highly recommended." William Perkins,
 - Author and former Allman Brothers Band Tour Manager

Table of Contents

Copyright © John Charles Griffin 2019

All Rights Reserved
ISBN: 978-1-6653-0586-0

This ISBN is the property of BookLogix for the express purpose of sales and distribution of this title. BookLogix is not responsible for the writing, editing, or design/appearance of this book. The content of this book is the property of the copyright holder only. BookLogix does not hold any ownership of the content of this book and is not liable in any way for the materials contained within. The views and opinions expressed in this book are the property of the Author/Copyright holder, and do not necessarily reflect those of BookLogix.

No part of this book may be reproduced in any form, except for the quotation of brief passages, or for non-profit educational use, without prior written permission from the copyright holder.

1

Junkyards
and
Green Stamps

This is the poem

The one that never ends
it will go on forever
riding a bus to your town
calling a taxi to catch
a ride to your house
It will knock on your door
bringing cards & gifts
for every occasion
waking you up from
an afternoon nap and
this is the poem that
joins you at the table
it will sleep on your couch
and wake you in the morning
this is the poem
that will turn on your stereo
and play your favorite song
dancing the night away
it will take away
fear of darkness
and share your secrets
it will open the wine
and serve you dinner
this is the poem
that will remove scars
and lift the heavy stars
of light years past
this is the poem
that lasts forever
it will agree with everything
that you've ever said and done
it will always come back
it will sense your energy
it will take you away
to the place you've always been
in a poem that lasts forever.

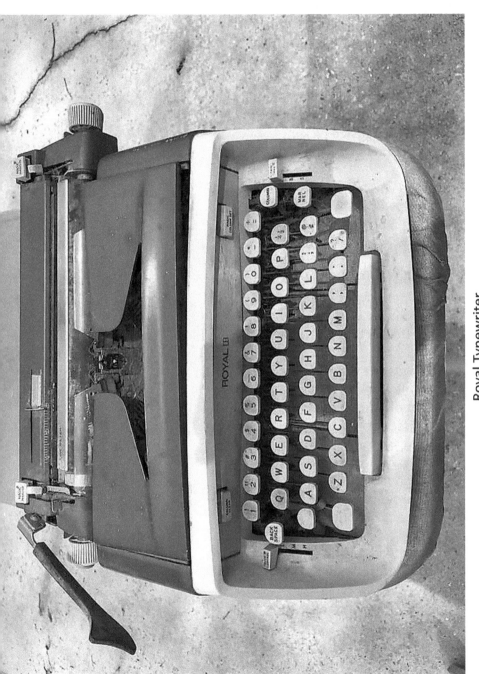

Royal Typewriter

Broken Water

Kicking, crying & screaming
born in a river of broken water
rambunctious crawling offspring
of an insurance salesman's daughter.

Daddy was a war veteran
farmed tobacco and cotton
Mama was a peach picker
with only one pair of shoes.

Grandpa was crushed
by a pulpwood driver
on dead man's curve . . .
when I was 4 years old.

Lightning rods wrapped around a steeple
with a cross over tin roof gables
the basement was a fallout shelter
where the service was preached.

There was dirt road adolescence
with time travel on gravel
in flight of birds & bees
on high school high wires.

Drive-in movie screen
carnal drive joy ride
pistol-proof attraction
teen-age satisfaction.

Miniskirt Kama Sutra
Americana pretty mama
rumble seat rock and roll
saxophone tropic zone.

Born in a river of broken water
compelled by wanderlust on tides
where weathered souls set free
have left their shells behind.

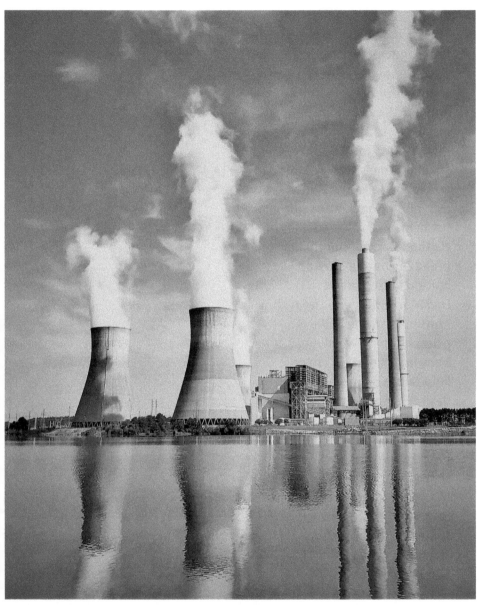

Lake Juliette Cooling Towers at Plant Scherer, the largest coal-fired power plant in The United States.

Sunday Matinee

There's a new incurable disease
the plague of all plagues
feared enemies lean & mean
that cannot be defeated
anti Christ evil empire
inside conspiracy jobs
big business food poison
small business closures
gun lobby sells more guns
sun lobby wants more sun
fist fight on a roller coaster
earthquake at a clambake
bread burns in a toaster
hair-pull disco brawl
Hail Mary cross your heart bra
nuns in the wine cellar
priests sipping whiskey
baby boom market crash
liquidation price slash
flash flood warning
river levels rising
trash in the gas tank
minds gone blank
Hell is frozen over
blockbuster monsters
best seller zombies
cyborgs and cannibals
chain saw thriller
Sunday matinee.

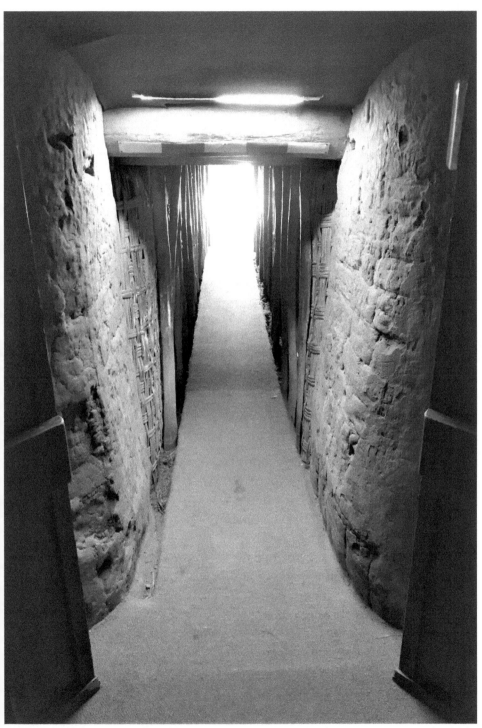

The Earth Lodge at Ocmulgee National Monument was built around 1,000 years ago to host tribal council events.

Shelter of Mercy

Slow to arrive early to leave
nothing more to say or believe
no kitchen left to offer
coffee or breakfast bar
no place to go for
a man with no car.

Souvenirs shine and
trinkets reveal times passed
dream catcher cookie jar
once sentimental reminders
of something become nothing
The shelter of mercy mission
a safe place to sleep and shower
no guns and knives allowed
offers warm beds and coffee
pullover sweaters and socks.

Cities are named at the bottom
of bottles with money back deposits
portals in time and empty space
musical chairs and revolving doors
with restrooms closed to the public
reminders of dancing light years
collecting tin cans in plastic bags
buckeyes and rabbit foot keychains
souvenirs shine, faces disappear
ambience comes and goes
spellbound undone.

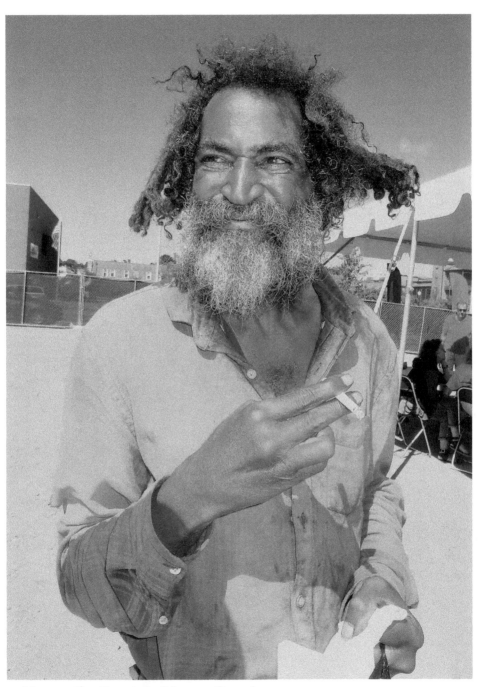

Man on the Streets in Macon, Georgia.

Blind Man

Trying to hold
back heart's
desire that has
no place to go
feeding poison
to thin endorphins
in a hungry stream
on a sea of dreams
blue horizon
gas pumps running
gin and sin and
wounds that healed
unleaded clouds and
beaches sunny
go with flow
on river running
Looking through the eyes
of an old blind man
at the darkness
yet unseen.

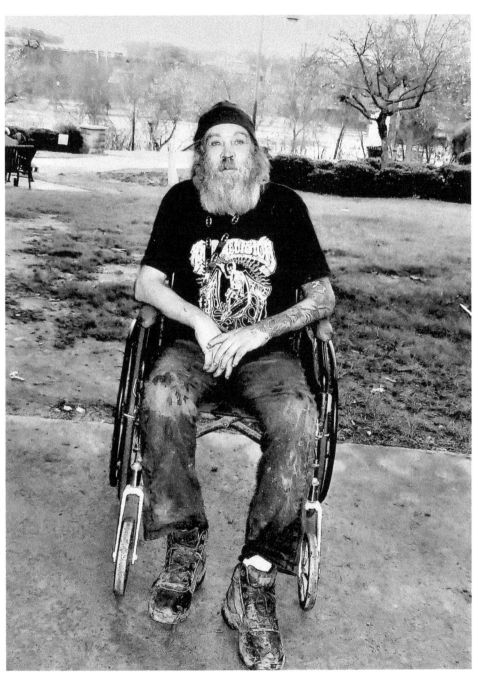

Homeless Man sitting in his wheelchair near the Otis Redding Memorial Bridge on the Ocmulgee River.

Amnesia Nostalgia

The endless war
lingers on between
amnesia and nostalgia
stem cells versus cancer
in trenches and ditches
understatues and flags
religion and politics
anthems and battle cries
soldiers and pacifists
gods versus mortals
temporary versus infinity
liberal and conservative
guns versus peace signs
men and women
enemies and friends
carnivores versus vegans
Hedonists versus Puritans
Christians versus Muslims
versus Catholics versus Pagans
Creole versus Raging Cajun
feline versus canine
time versus space
fire versus water
whispers versus screams
have-nots hired by haves
to make their beds
where nostalgia sleeps
late with amnesia.

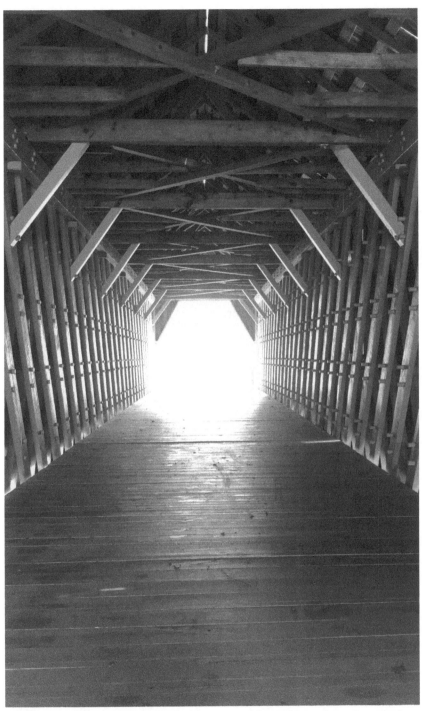

"There's Light at The End of The Tunnel." Auchumpkee Covered Bridge, originally built in 1889 near Thomaston, Georgia.

Hahira Gold Leaf

Hands cropped tobacco
bare feet got blistered,
calloused on hot ground
reaching for sand lugs
a tractor pulled a sled
between tobacco beds
in scorching summer heat
burning like a blast furnace
some years brought drought
often the dryer the hotter
irrigation rigs on wheels
drove water across the land
pumped from creeks and ponds
bream and catfish flopping
stranded on islands, sand bars
near fields of cultured harvest
khakied farmers read leaves
cooked with fire in barns
bales stacked high on trucks
destination tin roof warehouse
where country boys walked the aisles
sang "fresh peanuts fresh boiled peanuts"
standing in line a caravan of men
wearing hats and work boots
slow dance in a sea of gold
auctioneer rhythm and blues
sung by whiskey driven medicine men
weathered, sweet and dusty songs
fallout shelters signs at every turn
 Chet Huntley and David Brinkley
 smoking on the evening news.

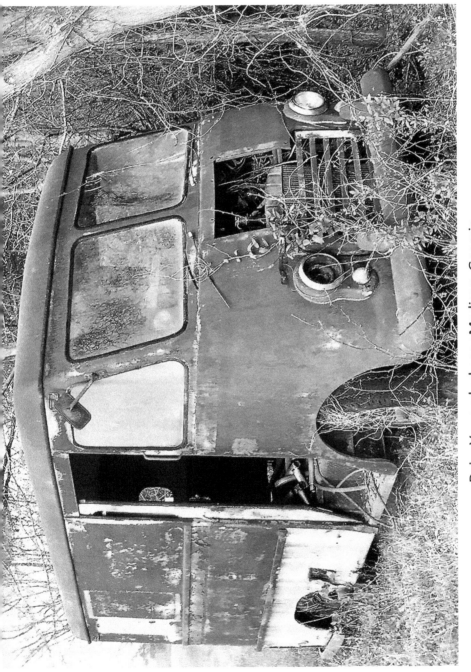

Dairy Van parked near Madison, Georgia.

Green Stamps

It was the best Christmas ever
daddy was a hard-drinking dirt farmer
in a season of drought when poverty and love were all we had
Granny bought three toy fire trucks with green stamps
the neighbors up the road hid our bicycles in their barn
mama made a gumdrop tree from a sticker bush,
me and my brothers played in a mud puddle
called it our swimming pool
fought over who would be the fire chief
and who would climb the ladder first
put out imaginary burning buildings
barefooted in the cold of winter
riding shiny bikes along a dirt road
retreated into a warm kitchen with Mama
who cooked dinner and baked apples
after the meal we smoked candy cigarettes
while daddy washed the Mercury
we'll never forget as long as we live
how mama could sing like an angel
"Sugar in the morning, sugar in the evening,
sugar at supper time."

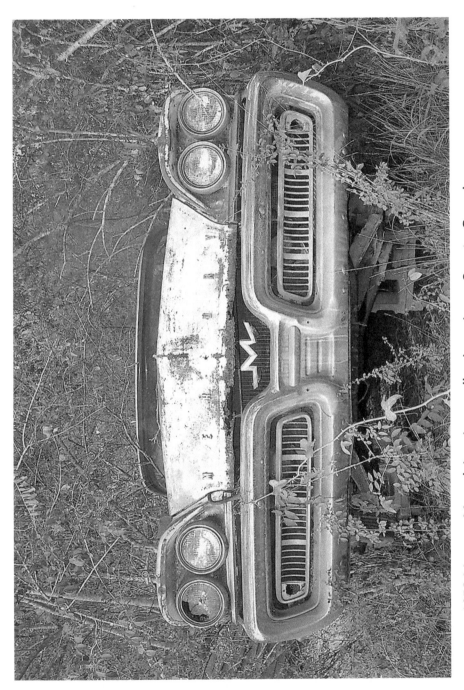

1958 Mercury Montclair, private collection – Jones County, Georgia.

NASCAR

Stock cars looking back
running on an oval track
fighter jets sonic boom
Hank Junior sings
Star-Spangled Banner
planes roar cars collide
Dale versus Cale
Sterling Marlin versus
Dick Trickle in a pickle
Fireball Roberts gone
up in towering flames
Junior Johnson running shine
Daytona 500 drag and draft
sling shot splitter spoilers
slick track brake fluid spill
Viagra car blue pill thrill
bumper to bumper
200 miles per hour
fist fights on pit row
spin out in a wall crash
Richard Petty crowned king
high fives beauty queens
figure 8 on the finish line
where checkered flags fly.

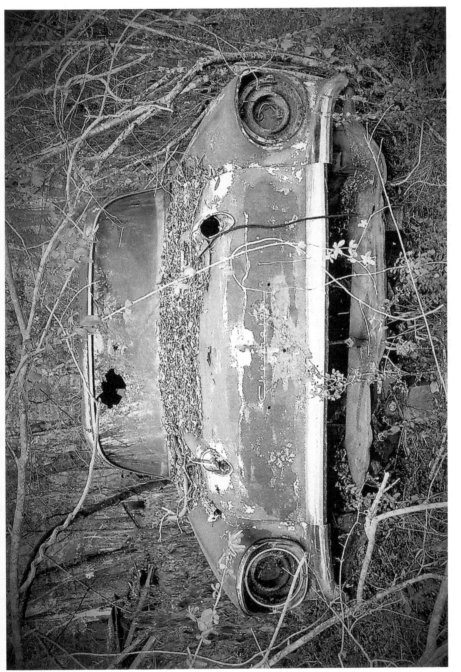

1956 Chevrolet Bel Air, private collection – Jones County, Georgia.

Junkyard love letter

Chakras grown weary,
endorphins stranded
bodies reprimanded
for losing themselves
in whiskey and sugar
to fill empty spaces
where libido wrestles ego
primal scream danger zone
in dreams awakened by
blue light sirens driving
to a crime scene or accident
while black sedan odometers at rest
await shade tree mechanics in junkyard
brake shoes, heartbeats and spare parts
driven by money and gravity,
blood, lust, smell, taste and touch,
ancient undiscovered treasures
found in a lost love letter.

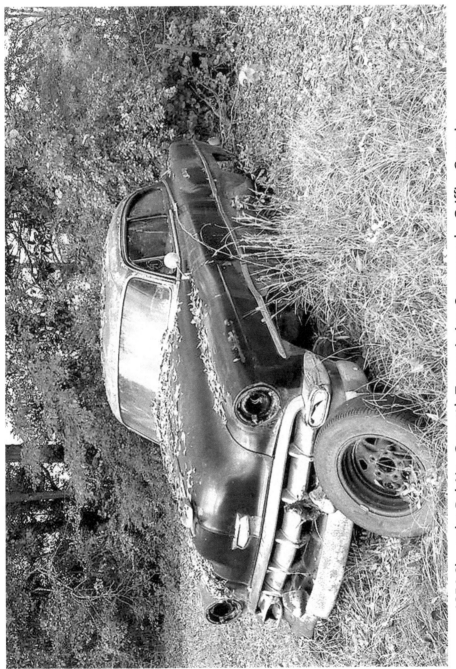

1954 Chevrolet Bel Air –Garrett's Transmission Compound – Griffin, Georgia

Limousine

Jack of hearts
from a trailer park
queen of diamonds
payday party time
firewater and fallen stars
baggage in the luggage
full house green room
all access tent revival
holy water medicine man
laundry on clothes line
cold beer on ice
ready to boogie
with a toast
to rock & roll
bended knees
shouting dancing
samba legs akimbo
dancing the limbo
hot to trot, see and be seen
in a camouflaged limousine.

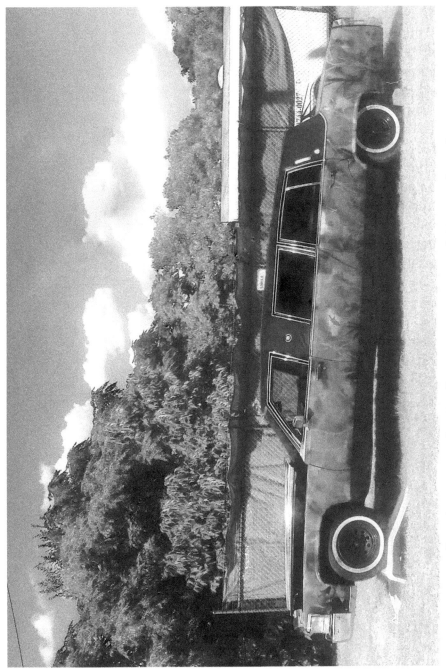

Camouflaged Limousine (Retired) Bay Street Retro-Junk Macon, Georgia.

G.P.S.

Smokescreen romance
Wounded kindred spirits
drawn close to passion
strings attached entwined
when sparks caught fire
scorched their hearts
on roads to wild desire
fuel injection system crash
burning tires, truth and lies
emotions shattered, broken glass
fragile caravans, lipstick and lust
miles traveled on freeways,
destination hunger and thirst
erotic road rage collision course
u turn curves in right of way
on turnpikes to the future
from past run out of gas,
slamming on the brakes
where love put to test on GPS
forever lost would never last.

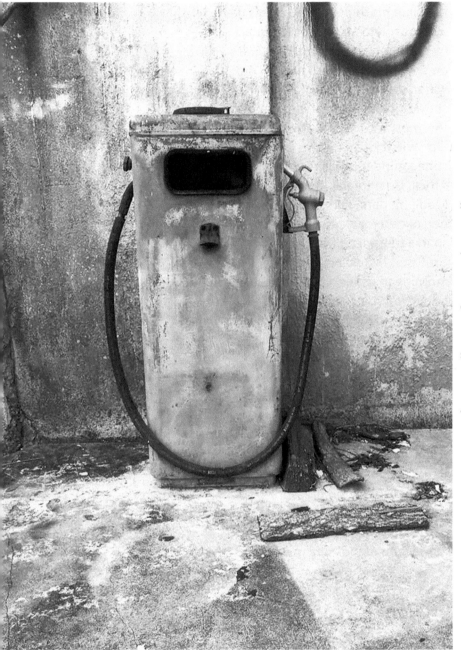

Vintage Gas Pump at Juliette Mill – Les & Lisa White Collection.

Morning Machinery

Morning machinery jump starts days
with obsolete alarm clocks replaced
by cell phones set to music
on and off determines hot or cold
water cleanses body and soul
shower giveth, hair dryer taketh away
thermostatic touch warms cool air
flip-switch kitchen lights brighten space
coffee grinder breaks imported seeds
Africa, Guatemala, Jamaica, Ecuador
Medium, dark, high test or decaf
percolated for sleepy heads
sparks to awaken the brain
confused by television news
morning machinery cuts grass
before summer heat sets in
chain saw cuts down trees
leaf blower clears the sidewalk
jet planes taxi on runways
motors growl, dogs howl
freight train hauls tractors
weather helicopter flies above
a semi-truck delivers groceries
traffic jams on an interstate
wrecker picks up damaged cars
nurses check blood pressure
surgeons repair broken hearts
with experimental procedures
in the land of morning machinery.

2

Alligators, Women & Guilt Trips

100 Goodbyes

Conversation began before language
more than a million years ago
recited in light of stars delivering
air, fire and water to the universe
power of adjectives connecting
kindred hearts in summer rain
sitting beneath an umbrella
leaving raging crowds of a city
where love and money come and go
passed thru gates of hell and back
souls connected by kindred spirits
hospitality and wine on a table
creature comforts never begged for
love and kindness reaffirmed
in a taxicab ride to dinner
music played and forgotten
where reemerging ghosts
sitin chairs on porches
of renovated houses
sleep beckons, dawn arrives
never enough words to say
goodbye a hundred times.

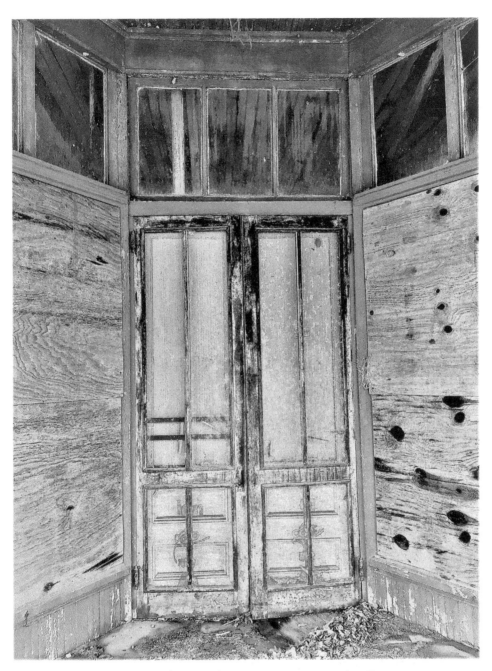

Merita Bread Company designed Doors were a popular fixture on country store entrances thru the first half of the 20th Century. – Marion County, Georgia

Guilt Trip

Guilt Trip Vacation
free travel package
no ticket or passport needed
you need not pass go
or collect two-hundred dollars
all you have to do
is live in the past
carry old baggage
suitcases full of garbage
a broken champagne bottle
you threw against the wall
arguments with a sibling or a parent
employer, spouse or lover
the motor that blew up
when you forgot to change the oil
the night you got drunk
threw up a gourmet dinner
in a four-star restaurant
a forged note you gave the teacher
after a week of skipping school
the dope you got caught with
that you said belonged to someone else
the time you broke your hand
punching a hole in the wall
the times you told the world
to go straight to hell
the show of a middle finger,
cars you ran off the road
stop signs and red lights run
the woods that caught fire
when you dropped a cigarette
and the unpaid gambling debts
so now that this guilt trip is over
you will survive the flames
everything will be okay
now that you're back
in jail again.

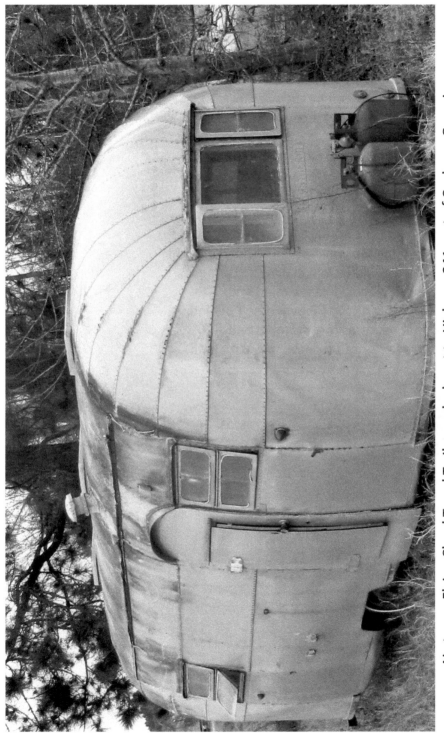

-Airstream Flying Cloud Travel Trailer parked next to Highway 341 east of Cochran, Georgia.

Taxi Cab Galaxy

There is a Galaxy somewhere out there
in that junkyard by the swamp
it used to be a fast car
now it's rusted out and gaunt
had a V-8 engine and a rumble seat
with whitewall tires an AM/FM radio
been trying to cry but can't find tears
looking back thru the lonesome years
where I see her face in a brand new light
through broken glass in the dead of night
like a mad dog bite in a tough cat fight
that's where I lost my mind and
took a taxi cab to leave myself behind.
that's where I lost my mind and
took a taxi cab to leave myself behind.

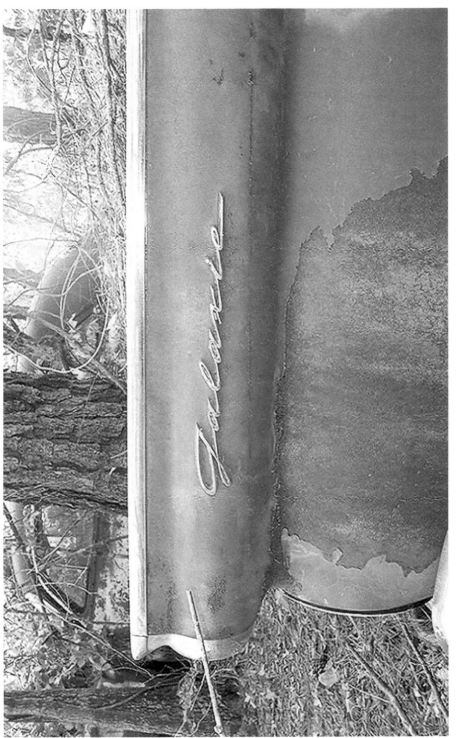

1957 Ford Galaxy Tail Fin

Women

The women he loved took up
with convicts, married men, gypsies
and bad mannered ne'er do-wells
where poverty of romance drives
drink to sink in depths uncharted
nicotine suicide a slow death
days without shaving or bathing
grief displaced by delta blues
ancient history of language
the chemistry of tears
saturated with sweat bead
landscapes in summer heat
endorphins drawn to candy and cake
taking the name of sugar in vain
awakened by coffee beans
delusions of grandeur a guide post
mapped out on a bus route
rolling across time zones
insomnia for weary bones
common law wives departed
passion gone in wild abandon
no dance partner tango
where ducks in a row
are drowned in solitude
buried alive by dreams
on a king size bed.

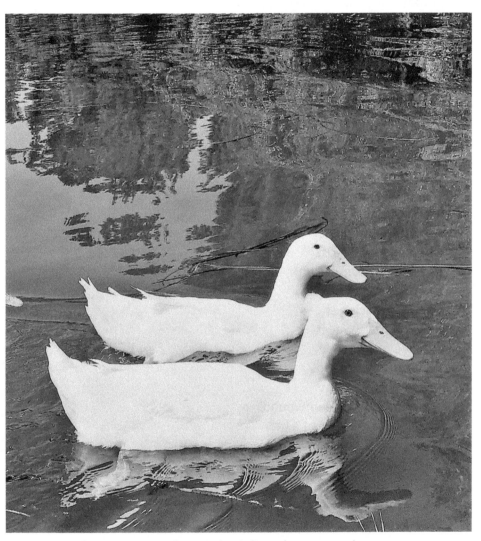

Ducks swimming along Lake Juliette's eastern shore.

Monkey Business

He was a man among many monkeys
she made a monkey of many a man
primates among inmates
blind dates on roller skates
she was the muse
or so she said in bed
while not in sense
of total eclipse
of musical monkeys
for he was a man
of many monkeys
where bonds grew strong
in love and trust
held by hands of time
in rhythm and space
where everyone lost
someone or something
an article of clothing
a pair of dancing shoes
a cell phone a wallet
the love of one's life
evolution of romance
smiles versus frowns
legs and hips come unwound
she made a monkey of a man
in a one horse town.

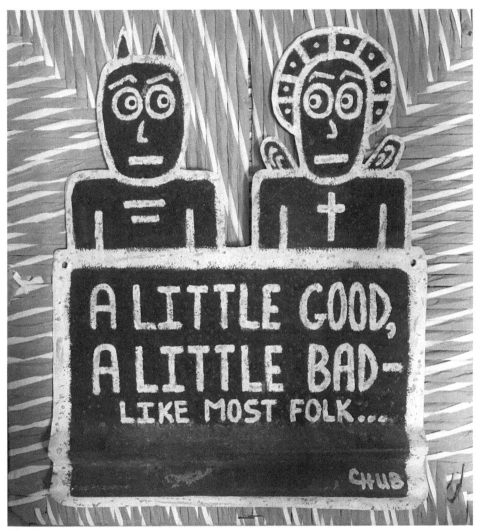

Rustic Art by Chris Hubbard @ Chubb Creations – Watkinsville, Georgia

Fortune Teller

The fortune teller calls
for order in the court
everyone is mad about
the future and the past
hardly anybody living in
the here and the now
screamers on a screen
take control of the deal
steal the vehicle and
peel the wheels
brake fluid burning
fire on a freeway
hubcaps turning
heartbreak yearning
snake bite karma
siren sounding
silent echo
silent echo
silent
echo.

City Never Sleeps

The Atlanta to New York City Delta 737 arrived during a blizzard in March that delivered forty-seven miles per hour winds, seventeen degrees Fahrenheit temperatures and touched down safely at LaGuardia Airport. The two of us took a limousine to our hotel on Manhattan's Upper West Side, enjoyed dinner in a nearby restaurant, attended a Broadway show, went to an after party in Times Square, bought three bottles of Pinot Noir at a liquor store, took a Yellow Cab north to 82nd Street and returned to our suite on the 37th floor when my traveling companion started to experience extreme hot flashes so we boarded the elevator to Level 52, went outside on the screened porch overlook deck with icicles hanging down from the awning, sat down in wicker chairs, smoked two cigarettes, had a toast to finish our second bottle of red, filled up a bucket of ice in the hallway and returned to room 3742 where she insisted on opening the windows which included safety locks required by New York City law to keep people from jumping. My lovely friend raised her voice and said, "you'd better open the damned windows," so we called hotel information and requested a maintenance person who arrived around three a.m. dressed in uniform, a pair of starched gray coveralls monogrammed with the name Carlos wearing a toolbelt full of custom gadgets, then proceeded to unlock two windows near the bed using what appeared to be an Allen wrench and looked at us as if we were crazy. We handed Carlos a ten-dollar bill, he said thanks and made his exit while we finished the last bottle with snow flurries blowing horizontally into the room through curtains onto blankets where dreams get laid to rest in a city that never sleeps.

Alley Cats 1985

Sunlight shines thru curtains and blinds
with bed-ridden hangover headache
sleep does battle with dreams
up too early, out too late.

Heart beats like a drum
pierced by trick-shot arrows
weather bones scream alone
down to the marrow.

Flowers grow in secret rooms
deals go down behind the scenes
spinning wheels on reel to reel
jackpot rings on slot machine.

Quick pick on power call
where wind chimes tell time
one more call for alcohol
in a taxi on a credit line.

Well-done over easy
twenty-four hour neon sign
take-out order in a paper sack
at the Dunk and Dine.

Never mind what's on the line
when dropping by for mixers
charmed by toast and jelly
with hungry moonlight fixers.

Red wine at the five & dime
where revved up primal urges growl
tulips bloom in twilight zones,
alley cats growl and prowl.

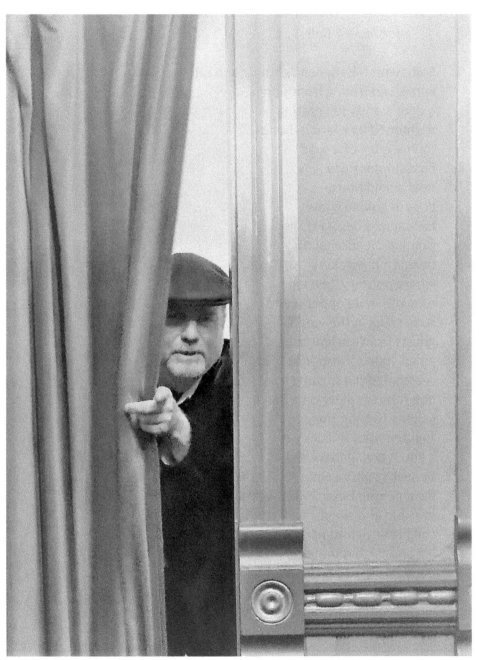

"Man Behind the Curtain" Adam Mosely celebrating the beginning of New Year's Day 2019 at Macon's Grand Opera House.

Lightning and Rain

for Jessica Betts

Somewhere between lightning and rain
witnessed from a front porch
a deer stands still grazing
frightened by roaring thunder
on the edge of a road
on a summer day
near a sold house
dogs in golden coats
bark across deep woods
running on adrenalin
beneath night skies
where mystery develops
a coyote or a copperhead
something in the woods
ghosts from ancient tribes
an episode of suspense
searching for a missing link
dog runs to safety on a porch
yelping turning circles
frightened by a black cat
a kitten crying in a creek
beneath vulture trees
disappeared beyond flashlights
invisible and silent
child returned to parent
life and birth reunited
between spirit and light
celebrating the unknown
where water and wine flow
quietly in a safe place.

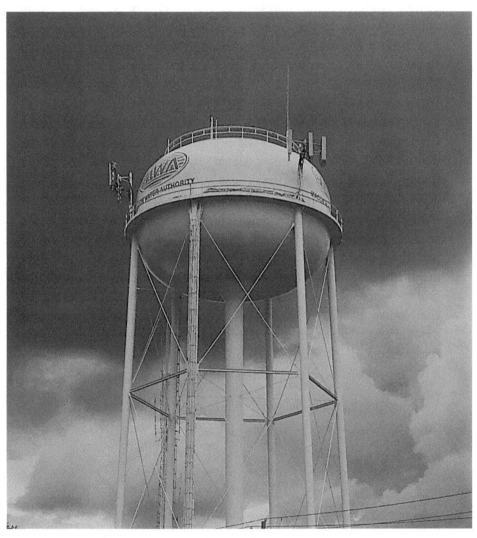

Tornado Warnings at The North Macon Water Tower.

Old Jim the Alligator

I was born and raised on Griffin Drive across the cotton field from a cypress swamp a couple miles east of Hahira. One of our neighbors, an elderly fellow named Will Jones who lived near our family farm, kept a pet alligator named Jim under an oak tree in the yard that he and my Uncle Ivy found in a creek and adopted when they were young boys. They fed him chickens and rabbits. Mr. Will and his coon dogs loved that gator like a family member and *The Atlanta Journal* folks drove to South Georgia in the mid 1960's to write a feature story about it. People used to drive for miles to see Old Jim at the Jones place located near Val-Del Road. Will Jones never would say specifically how part of the middle finger on his right hand was missing. That local alligator was Hahira's biggest celebrity back then in more ways than one. He was right up there with Billy Joe Royal who was from the same neck of the woods. I remember a time during my childhood when Old Jim escaped and disappeared for a few days. The Jones boys (Elijah, Will, and Robert) drove for miles up and down dirt roads in a pickup truck with several coon dogs riding in the back, looking sad-eyed while searching for their beloved alligator. The Val-Del farming community breathed sighs of relief when Jim returned home a few days later after The Jones family removed one of the anchor cross ties, cut an opening in the pen and left a couple of live chickens as special gifts tied to a fence post.

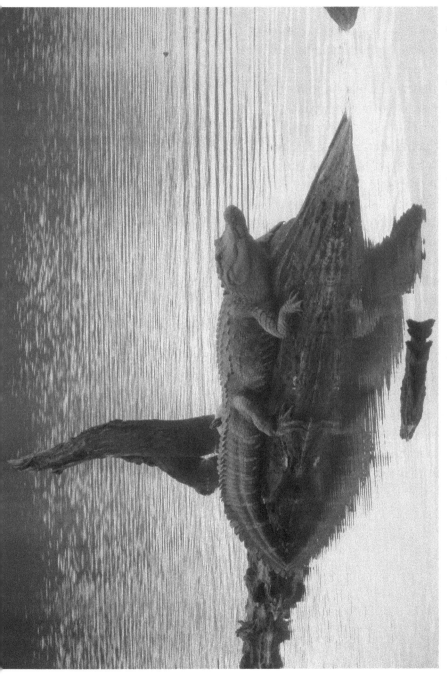

American Alligator basking on a log in The Clay Pond at Ocmulgee National Monument. This reptile species has been around for approximately 150 Million Years.

Pig Dreams

"This little piggy went to market,
this little piggy stayed home."

Time travel while napping
it was like that every year
after Thanksgiving remembering
welcome warmth in a kitchen
when Mama called her boys
"The three little pigs"
where love and sweetness
baked cookies and sang songs
when the whole universe was
located in a small house on a dirt road
leading to a town of less than 1,000.
Awakened from the dream he smiled
blessed with a comfortable home,
a new couch and food in the fridge,
art on the wall, books and things
downsizing provided more space
to reach out, help others celebrate
what little we have on the outside
that is always fullness within
remembering his mother's love
on the way back home.

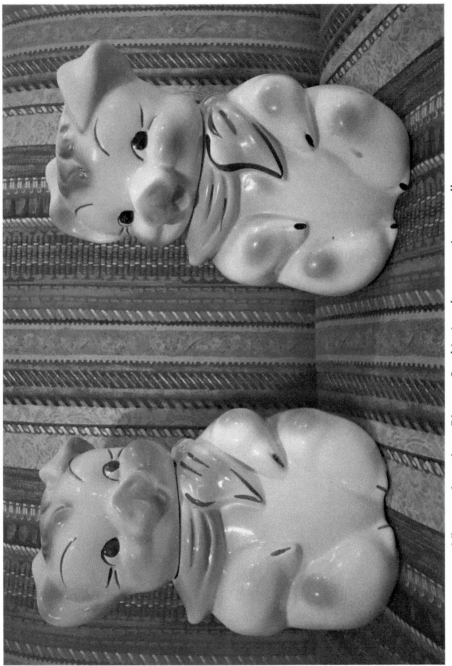

Vintage American Bisque Cookie Jars have stories to tell.

Family Feud

There's a family feud
on every corner
to try and figure out
who gets the kids
who gets the dog
who gets the house
who gets the boat
who gets the gun
who gets the knife
who gets the mine
who gets the shaft
who gets to cry
who gets to laugh
who gets fortune
who gets fame
who runs wild
who gets tamed
who gets the car
who gets their name
on a Hollywood star.

Blame Game

Blame the dad and blame the mom
Blame the drugs the kids are on
Blame the matches blame the fire
Blame the motor blame the tire
Blame the players blame the fans
Blame the woman blame the man
Blame the moon and blame the sun
Blame the bullet and blame the gun
Blame the driver blame the drink
Blame the kitchen blame the sink.
Blame the truth blame the lie
Blame the ears and blame the eyes
Blame the veggies blame the meat
Blame the hands and blame the feet
Blame the pots blame the pans
Blame the bottle blame the cap
Blame the highway blame the map
Blame the lotion blame the tan
Blame the carton blame the can
Blame the bullet blame the gun
Blame the moon blame the sun
Blame the beauty blame the beast
Blame the criminal blame the police
Blame the most & blame the least.
Blame the Vodka blame the Gin
Blame the rooster blame the hen.
Blame the family blame the friends
Blame the sinner blame the sin
Blame the beginning
Blame - - - The End.

Bob Dylan

Caught a ride to the box office
with a county commissioner
rock & roll Rabbi retired
elected to public office
business and finance director
we stood in line to buy Bob Dylan tickets
surrounded by Jehovah's Witnesses
talking about libraries closing
bus line cancelations
weather in France, sister city
and garbage pickup fees
weary bones and rolling stones
tax plan compromise
Dylan got the Nobel Prize
with money running out
inside votes to settle scores
gospel music in the background
bible belt culture in decline
consolidation and trepidation
private versus public education
political unrest put to test
orchestra seats row seven
American Express Gold Card
knocking on heaven's door.

3

Glass Houses, Groceries and Greyhounds

Apple and snake

Snake bitten force fed Apple
silicon gambling chips
silly con artists
serve spam to the masses
song dance techno disco
Nabisco cookie throw
game store download
not an ordinary snake
not an ordinary Apple
take another bite
a thousand megabytes
crescendo gigabyte
eliminated snail mail
personal history copyright
online garage sale
liquidation trepidation
success smell taste test
finger print sign in
facial recognition clone
future past present known
virtual microscopic DNA
microchip on roulette wheel
GPS surveillance drones
online offline fly high
Anaconda in the rumble seat
Cobra on the running board
fig leaf conspiracy theory.

.

Deodorant Row

Supermarket deodorant row
Zinc-Free Extreme Defense
Bear Glove Wolf Thorn Body Heat
Nourish Sweat Buster
Dry Idea Clinical Strength
Walla Vegan Wild Stone
Lemongrass Fresh Scent
Chrome Denali Pheromone
Speed Stick Stress Control
Arm & Hammer Crystal Body
Herbal Cowboy Adrenaline Rush
After-Hours Lasting Legend
Hot Lavender Honey Bee
South of France Jungle Man
Meow-Meow Woman Cream
Time Release Molecules
Organic Primal Pit Paste
Obsession Roll On.

Tomahawk

The fearless leader called the shots
to take down all the trouble spots
so they bombed the entire world
into submission
and when the war was over
they fired shots at the moon and sun
did a victory dance with cigars lit
flipped the ashes with no regrets
arrested those who dared protest
canceled all their unpaid debts
built more long-range missiles and jets
blessed the bones of those who died
drank the tears of those who cried
arrested those who dared protest
built more long-range missiles & jets
flipped the ashes with no regrets
the fearless leader called the shots
to take down all the trouble spots
so they bombed the entire world
into submission.

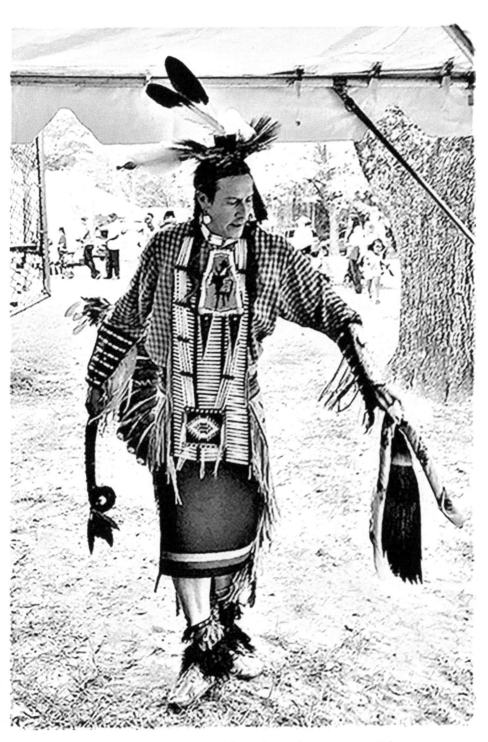

Muscogee Creek Nation Tribal Elder adorned in ceremonial
dance attire at Ocmulgee National Monument.

Post cards

Post card collections stored in attics,
pictures, images and memorabilia
show evidence of lost continents,
mountain retreats, museums,
state lines, national parks,
keys to hearts of memories
Mary Magdalene in Rome
coliseum gladiator body armor,
bull fighter in Barcelona
Parisian can-can cabaret
Moulin Rouge windmills
Badlands, South Dakota
Central Park Broadway Empire
Sweet Land of Liberty
Las Vegas neon roulette
Low Country plantation scenes
red-tailed hawk flying over a desert
San Juan cats and catamaran
Virgin island Pirate lore,
The Golden Gate Bridge
places traveled on a globe - - -
weathered statue landscapes
in light from dawn to dusk,
shine then fade in shoebox dust.

Panoramic Cherry Log Mountain near The Appalachian Trail - Blue Ridge, Georgia

The Bakery

Sugar monsters in Candyland
gnawed toes off the blind man
wheelchairs at the food fair
whipped cream, milk shake
upside down banana cake
chocolate Easter bunny
wedding cookie matrimony
donuts and dental floss
honey baked cream puff
sex drive appetite satisfied
 with apple pie and moon pie
celebrate life, laugh and cry,
eat, drink, love and die.

The Grocery Store

Push cart near-miss head on collision
cooking demonstration on aisle seven
wheels roll between bacon and beans
Oriental shoppers converse in Chinese
a Latin-American baby cries in Spanish
lawyers say hello to plumbers
guitarist speaks to a drummer
blue-haired ladies sort thru coupons
automatic teller machines spit bills
store clerks take smoke breaks
rain forest sounds cool shoppers
summoned to buy exotic fruits,
hunters forage for nuts and berries
peanuts, guacamole and pomegranate
a woman arrives from yoga class
hypnotized by the fresh fruit lane
making eye contact with bananas
trying to decide between six or seven
green or yellow which bunch to buy
a line develops monkey see, monkey do
jungle sounds on edge of dance, primates,
cat calls, waterfalls, sharp claws
mesmerized she stops and hesitates
a stock boy with a snake tattoo
looks across oranges and grapes
hands her a shiny red apple,
his right arm says "Garden of Eden"
while she fills her cart with fig leaves.

After the dust

After dark clouds cleared
the actor and actress went
their separate ways
moving on to new roles
changing casts of characters
some from the future others
from the past where scripts
brought comedy and tragedy
laughter and tears
memories of years gone by
mildew fog and frost
battles won and lost
fame and celebrity
marriage and divorce
roulette wheels, bets on horses
match games and jeopardy
where regret became gratitude
or the other way around
accelerated by attitude
where rising and falling
stars play hide and seek.

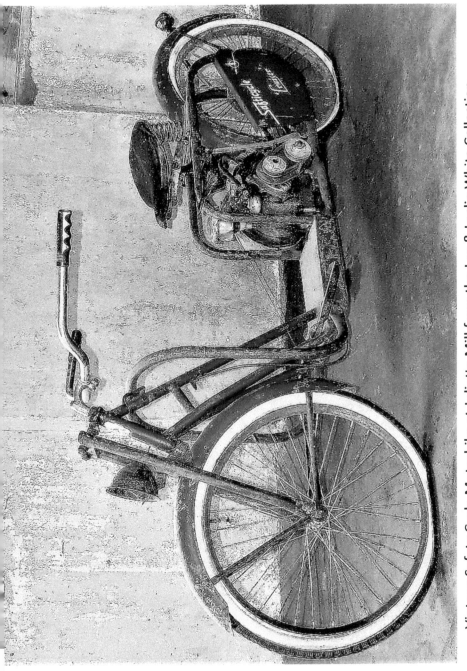

Vintage Safety Cycle Motorbike at Juliette Mill from the Les & Leslie White Collection.

The Tour that Never Ends

It got tough watching the old cats
singing songs for their supper
reach to fill their purses and wallets
sixties seventies rockers hobble across
stages, some with canes and walkers
products of gravity and weathered bones
their vintage guitars shaped from trees
and imported wood some of it banned
and quarantined from import
to save the rain forests
some smuggled across continents
It got tough watching the old cats
long in the tooth with bridges and crowns
claws still reaching to scratch
wild desires of ancient fires
camouflaged In body paint
circus parade on Main Street
babes shaken on front rows
follow the everlasting band
twenty thirty forty years or more
with backstage memories
testosterone meets estrogen
one more ride for old times sake
when hourglass runs low
on erotic sands of time
thongs long gone
dancing shoes moved by
rhythm of old gray rock stars
with receding hairlines
boxer short undergarments
changing of the old guard
to a new improved sonic boom
flying Wallendas falling off
the high wires in their hearts.

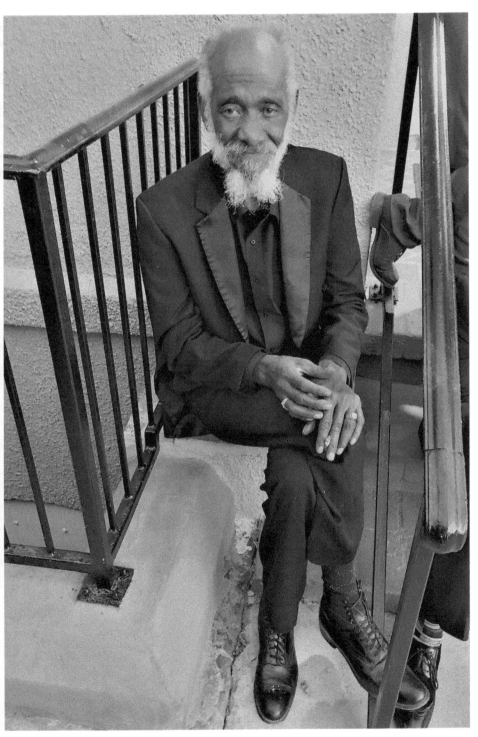

Robert Lee Coleman, blues master, King of "The Chitlin' Circuit'", former James Brown Lead Guitarist and Band Leader.

Forget the world

Forget the world be strong
be the rhythm be the song
do all you can to get along
become belong
abandon gloom
be right be wrong
beware the drones
avoid the clones
in danger zones
forget the world be strong
be the rhythm be the song

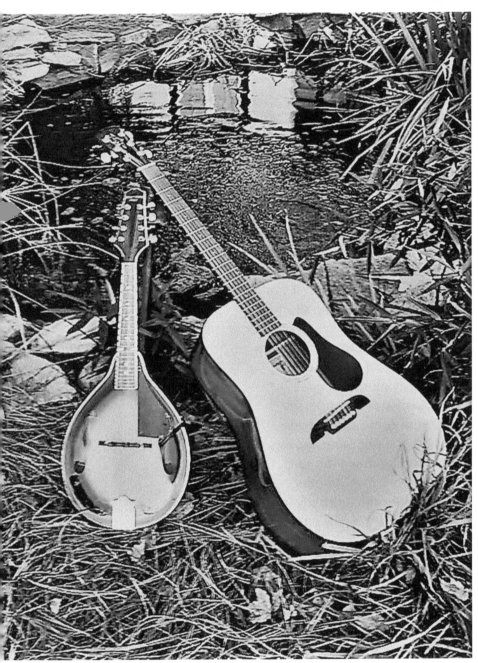

Mandolin and Guitar in the back yard of The Allman Brothers Band Museum at The Big House.

Red Toaster

The warmth of a red toaster
a house-warming gift that fixes
bagels, bread and pop tarts
memories of luxury hotels
friends and family runway taxi
souls migrated place to place
vacations in paradise lost
late arrival quick departure
seconds minutes hours
timer left on too long
remembering and forgetting
burning bread, crumbled crisp
ambience and gratification
between folds of kindred souls
recalling when a plain toaster
stood quietly on kitchen counter
old school before red flags flew
practical quaint more basic
joined by morning coffee
awakening daylight senses
in these come and go lives
where the exit ramp appears
a few miles down the road
we care we love we miss
hospitality and motherly love
with butter and jelly on toast.

Food for Thought - Vintage Red Toaster Replica - Gift from a Friend

73

Glass House

Hollywood Star postage stamp
circus parade exit ramp
bumper car glass house
bearded lady after-shave
fortune teller vacation
weight guesser hunger strike
anger the square root
of reality television
divided by fear
tele-market cold call
quick pick powerball
a hole in the net
where acrobats fall
you've just won
a trip in a barrel
over Niagara Falls.

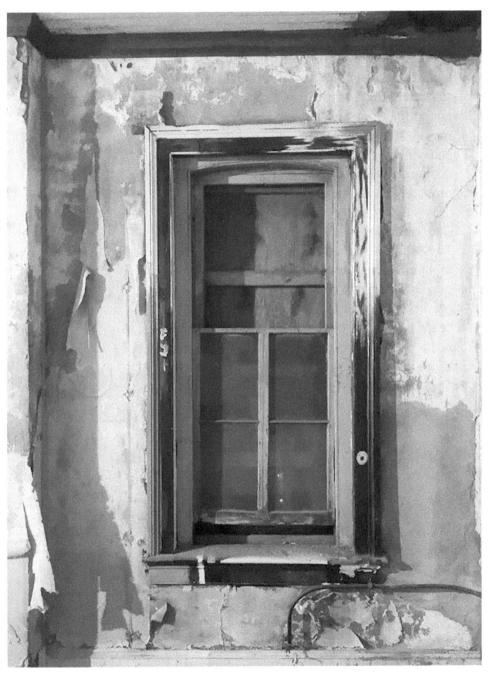

Window to The Soul from an old house falling down in Jones County, Georgia

Homeland Insecurity

Think tank ramblers and talk show hosts
capture minds of masses with television anchors
talking models weather studs and beauty queens,
good looks and cleavage feed market shares,
money for missiles approved by congress
general dynamics and world banks
evangelists in Armani suits
mobster stripes and shiny shoes.

Congress chokes on Snoop Dog bones
The Senate vetoes clean water
Vladimir Putin and the hands of fate
play upside down chess in cyberspace,
motorscooter paper boys on zulu time
sell wall street tabloids owned by China,
border patrol tunnel vision land of milk and honey
Wal Mart, secret service, aliens and opioids
fill gaps and voids

Greyhound Express

He travels light cross country
guided by tunnel vision
relaxed rolling on a four lane
in a newly built Greyhound bus
Savannah enroute to Macon
nine passengers on board
chosen few, cosmos mariners
destination unknown . . .
picking lucky numbers on
roulette wheels of karma
traveling north on I-16
through dark swamps
teeming with reptiles
nirvana incognito . . .
somewhere else faraway
people read fortune cookies,
while singing and dancing
riding in limousines
of past lives progression
looking for the holy grail
on a cool, cloudy night
where alligators and snakes
beneath a concrete bridge
protect their eggs from predators
thru the windows of a Greyhound Bus.

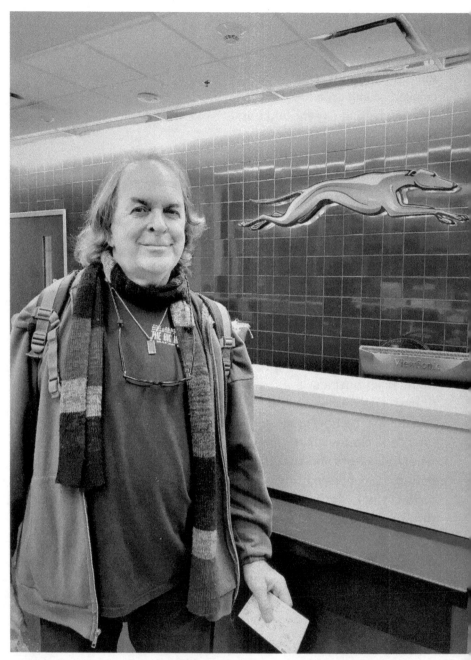

Author John Charles Griffin ready to board Greyhound Express from
Savannah to Macon, Georgia.
Photo credit Elfrida DeRenne Raley

The Poet

John Charles Griffin is a poet, photographer, musician, a 1984 graduate of Valdosta State University, with a Bachelor of Arts Degree in English Literature. His first book, *After The Meltdown,* was nominated for a 2016 Georgia Author of The Year Award for Poetry. Griffin is a Macon, Georgia native and serves on The Board of Trustees with The Allman Brothers Band Museum at The Big House. He is a U.S. Navy Veteran having served with U.S. Middle East Forces in Bahrain and Mediterranean Fleet based out of Italy. His poems have appeared in anthologies *Java Monkey Speaks, Shades And Shadows, Silver Valley Voice, And Velvet Crescendo.* Griffin has performed spoken word in Atlanta's Callanwolde Arts Center, Decatur's Java Monkey Coffee House, Avid Books of Athens, Macon's Sidney Lanier Cottage, Gallery West and Valdosta's Turner Arts Center. His photographs have appeared in *Macon Magazine, Georgia Music Magazine, Gritz Magazine,* and *Kudzu Online.* Griffin spent his early years working and playing on a family farm near Hahira, Georgia.

Cover Artist

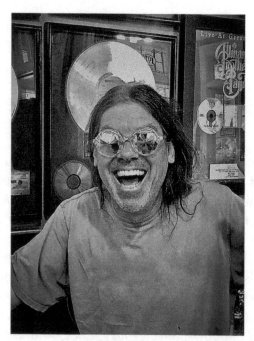

Johnny Mo

John Mollica created the cover art for this book using a photograph by the author. Mollica is a self taught artist who started his career in Memphis, TN as a screen printer, using tee shirts as a vehicle for his art. Over the years he has produced art for album covers, show posters and merchandise for dozens of unknown bands and a few that are more recognizable. Today, Mollica lives in Macon, GA with his girlfriend, son, and chicken. His paintings are recognized as part of the new Absurdist Movement centered in Middle Georgia. He creates art and merchandise for the Allman Brothers Band Museum at The Big House and for the world famous Grant's Lounge. He also functions as steward for Local 47 of Macon, a union of artists and musicians at large.